How to
Draw
for Kids

Dylanna Press

Learn to Draw Step by Step!

Learning to draw doesn't have to be hard. This book will show you how to draw 45 projects one step at a time. All you need is a pencil to get started.

Each diagram on the left shows you how to draw the object step by step. Simply follow along drawing in the space provided on the right-hand side. Add each detail as shown until the picture is finished.

Start off drawing lightly and don't worry about making mistakes. You can always erase and start over.

When you're finished, you can add your own details and color it!

Have fun!

Horse

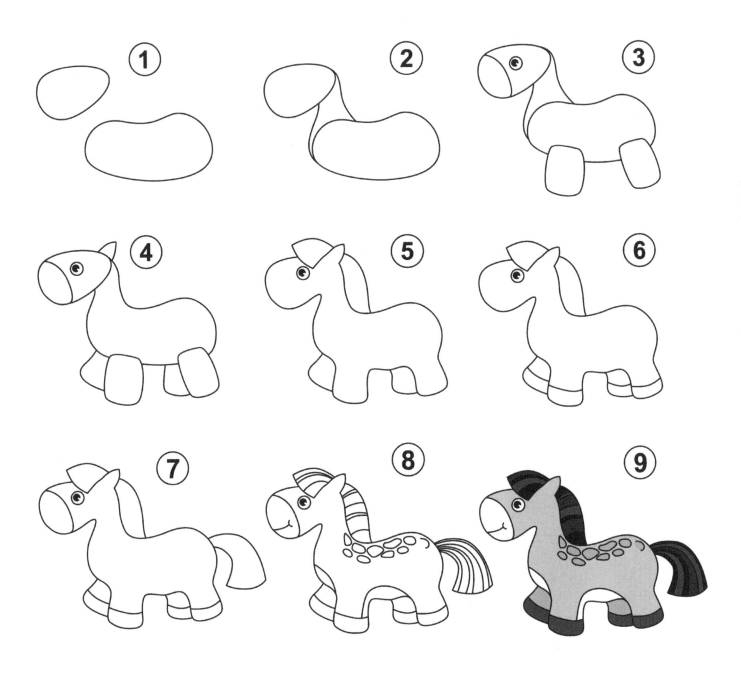

Your Turn to Draw

Dolphin

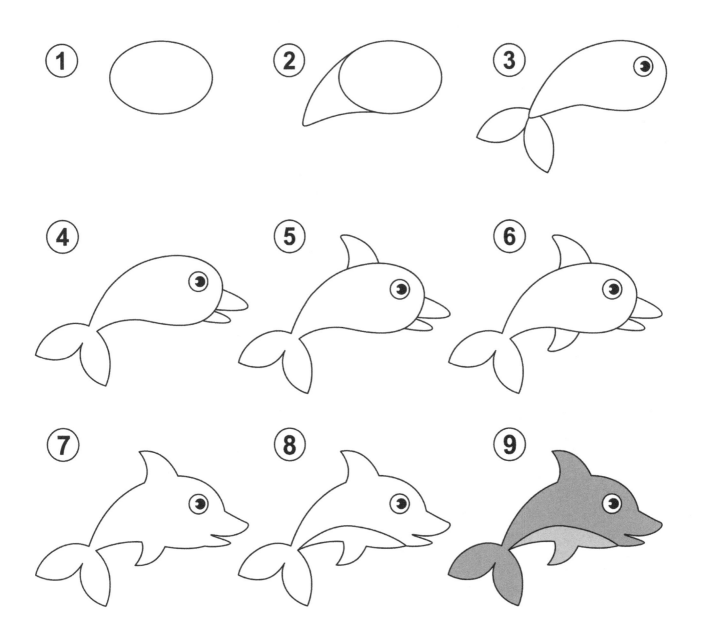

Your Turn to Draw

Sun

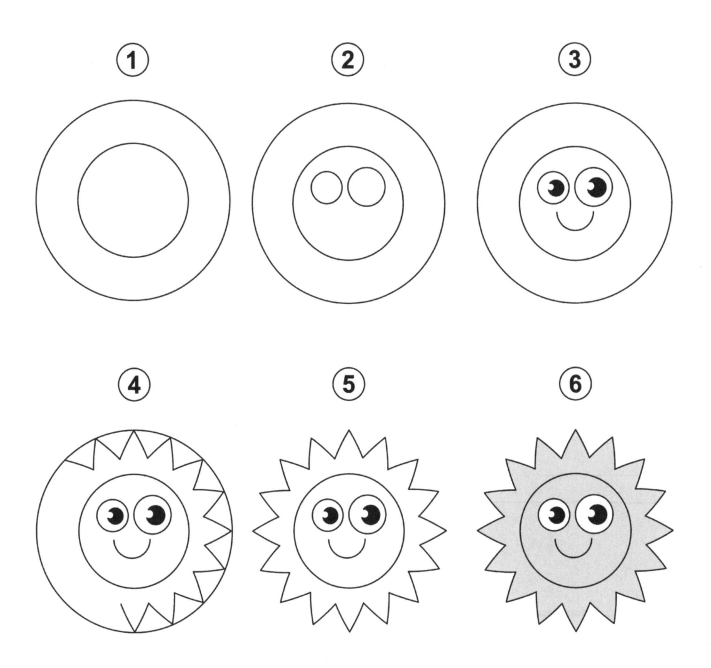

Your Turn to Draw

Elephant

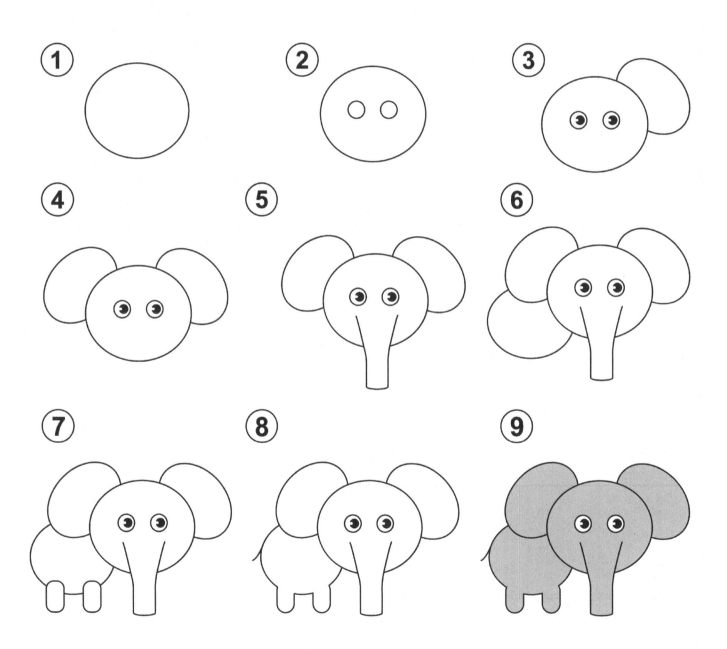

Your Turn to Draw

Flower

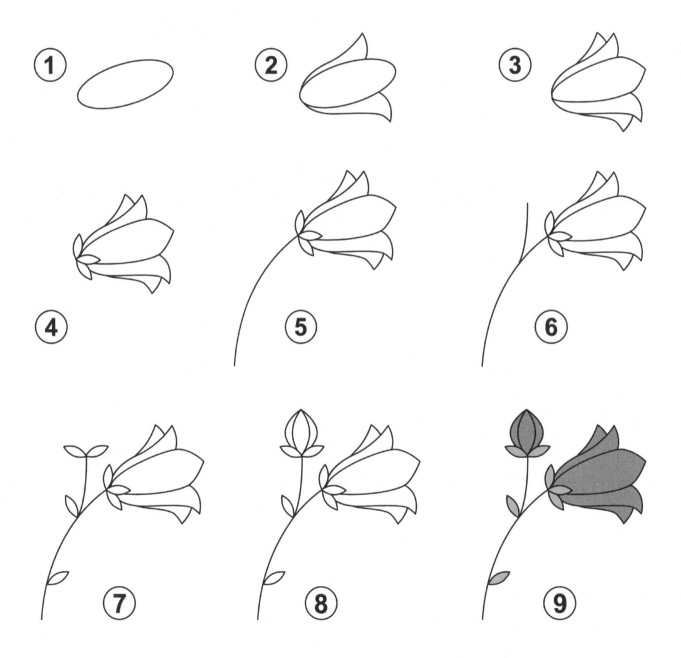

Your Turn to Draw

Bow

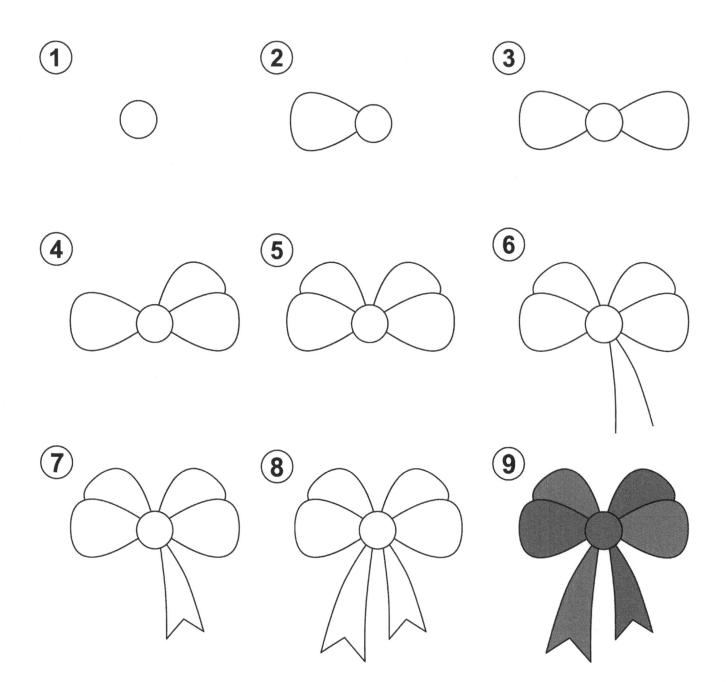

Your Turn to Draw

Jellyfish

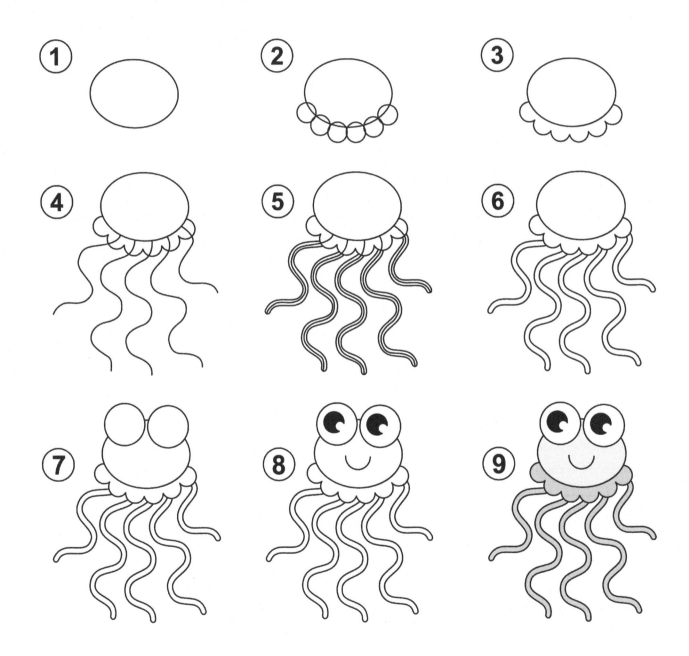

Your Turn to Draw

Turtle

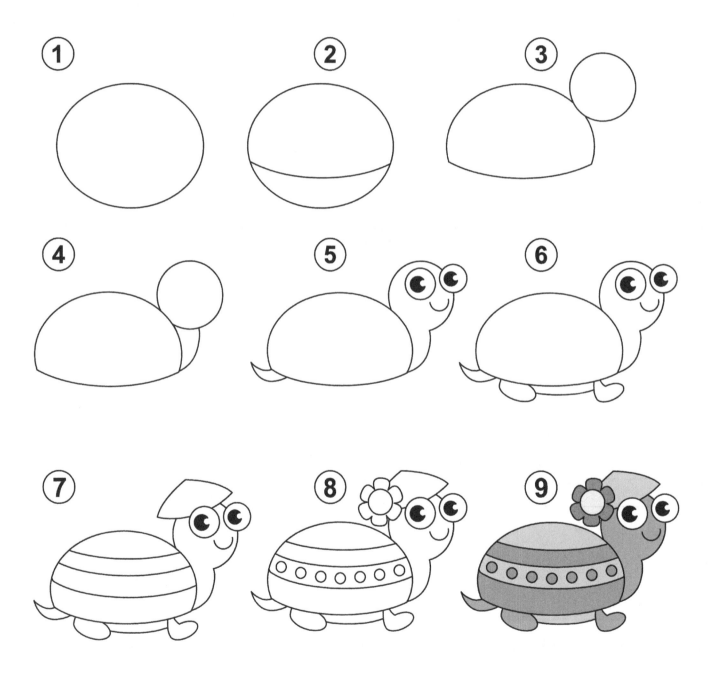

Your Turn to Draw

Sailboat

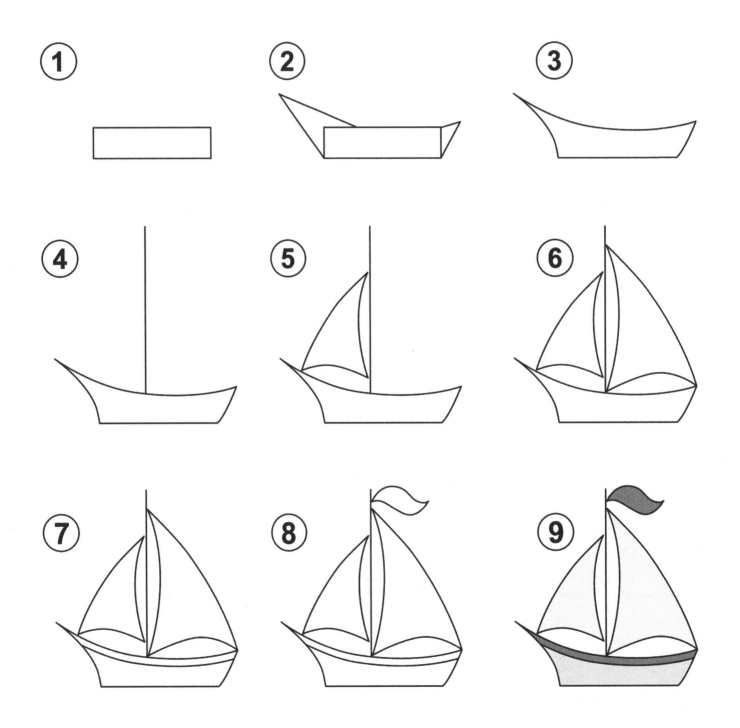

Your Turn to Draw

Rocket

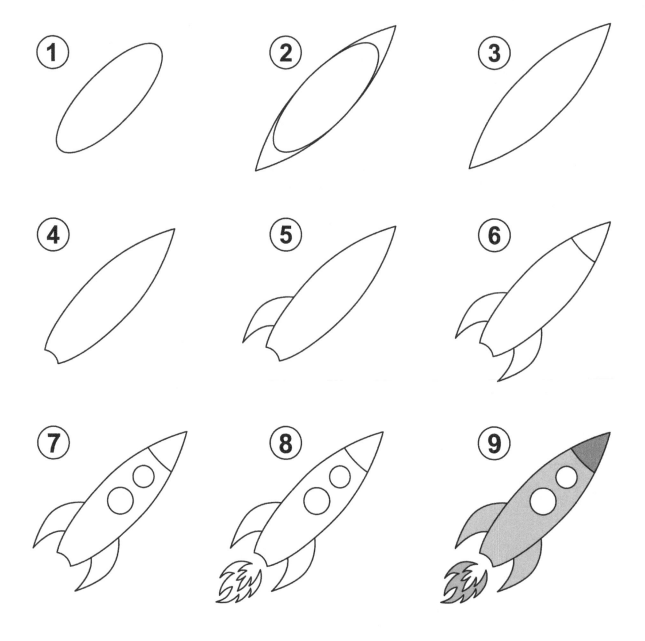

Your Turn to Draw

Cat

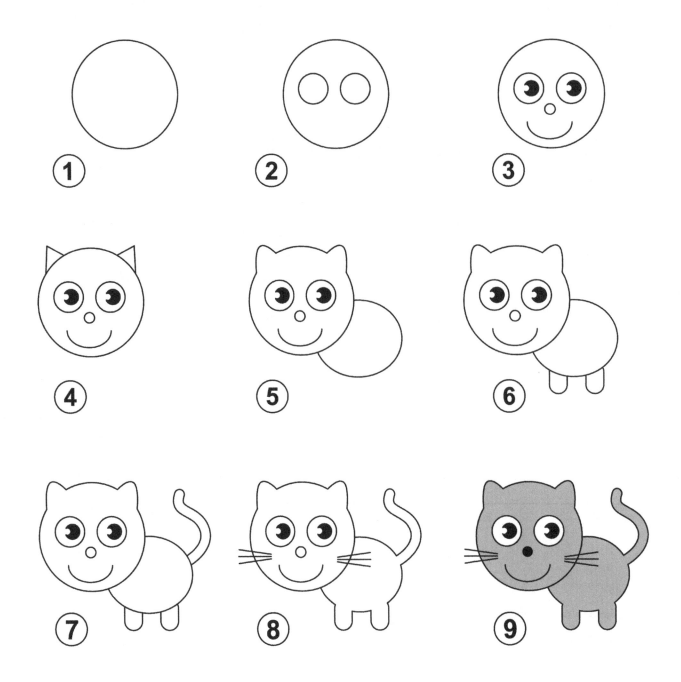

Your Turn to Draw

Fish

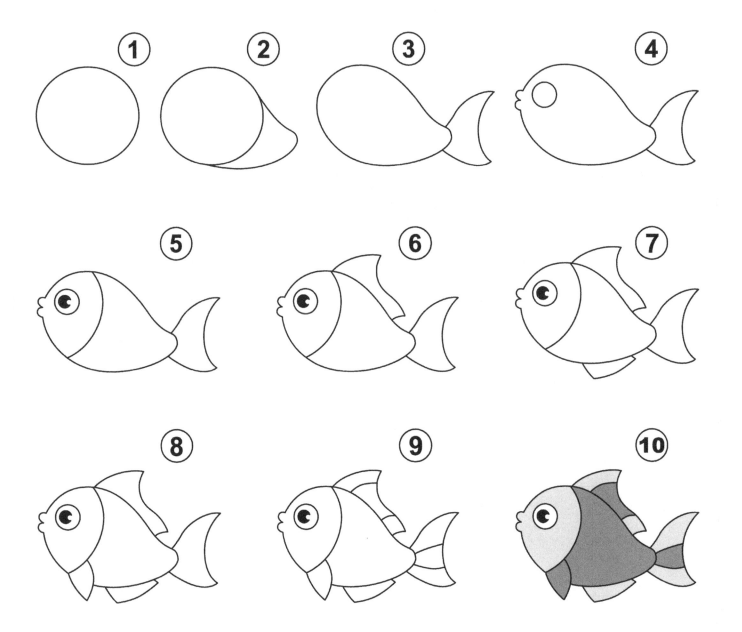

Your Turn to Draw

Globe

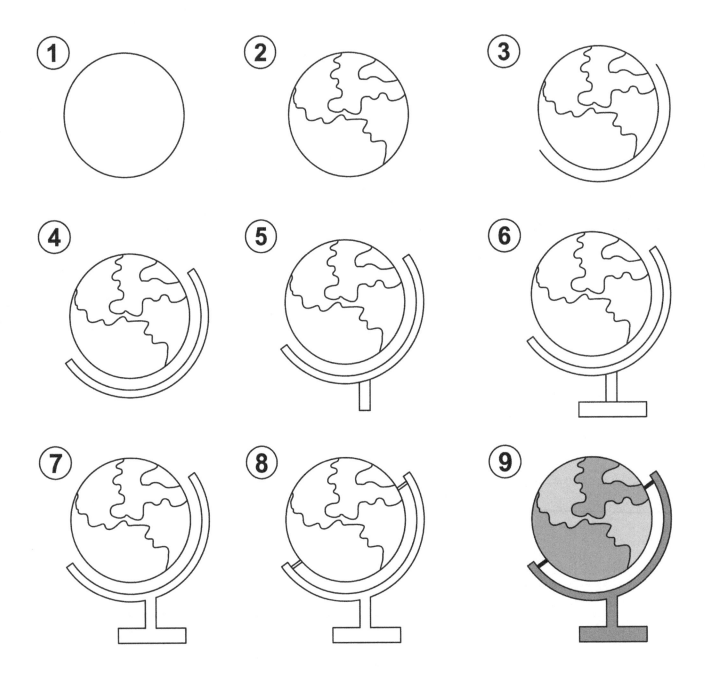

Your Turn to Draw

Umbrella

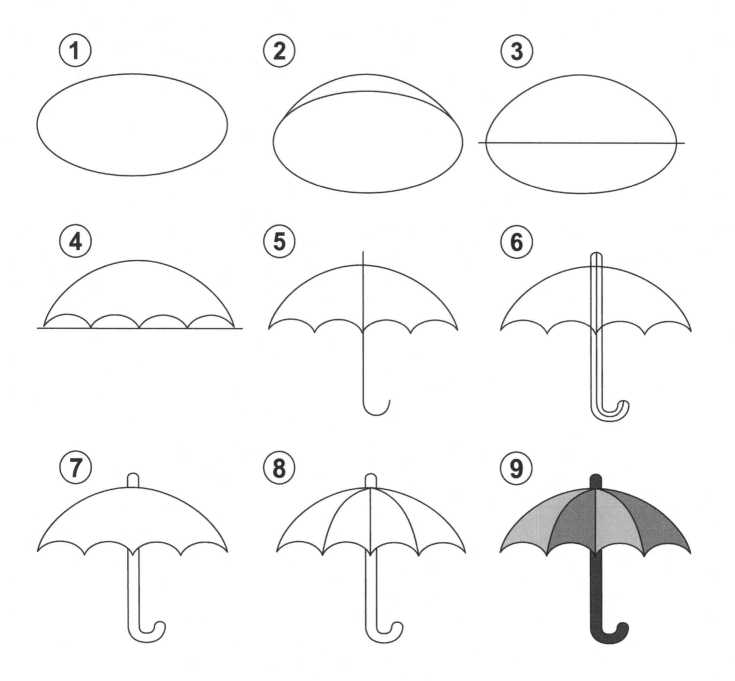

Your Turn to Draw

Flowers

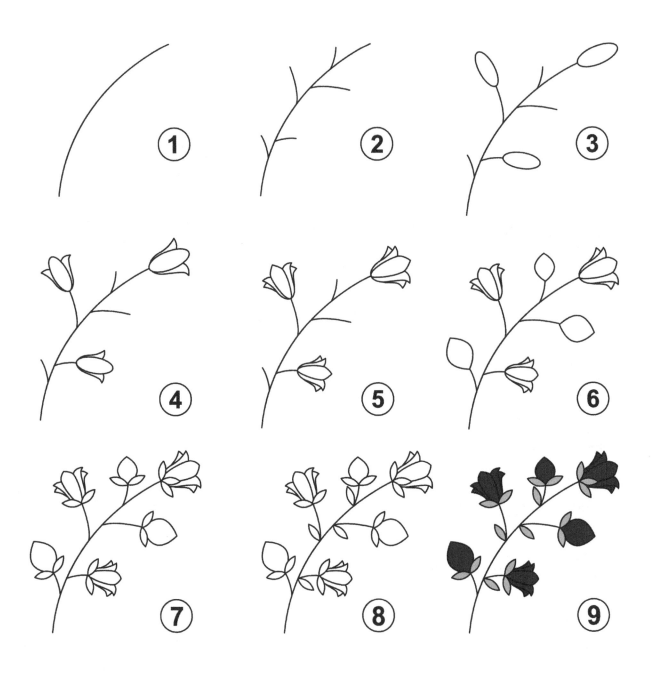

Your Turn to Draw

Pear

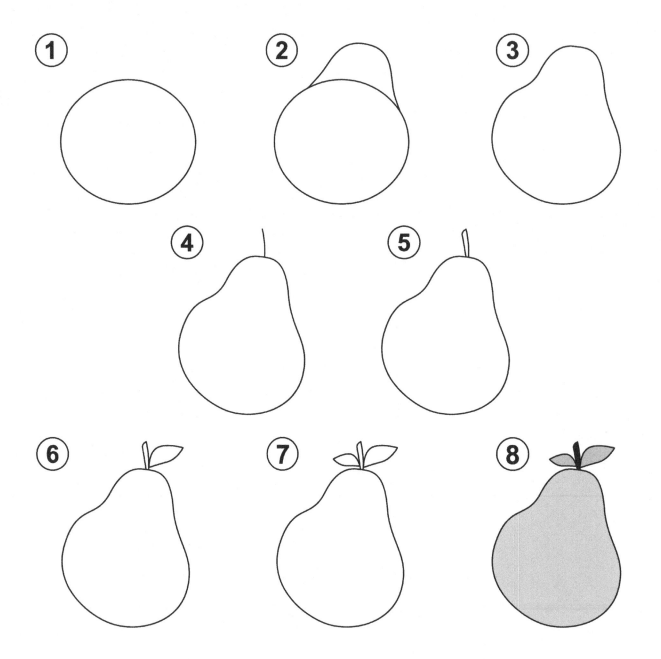

Your Turn to Draw

Lemon

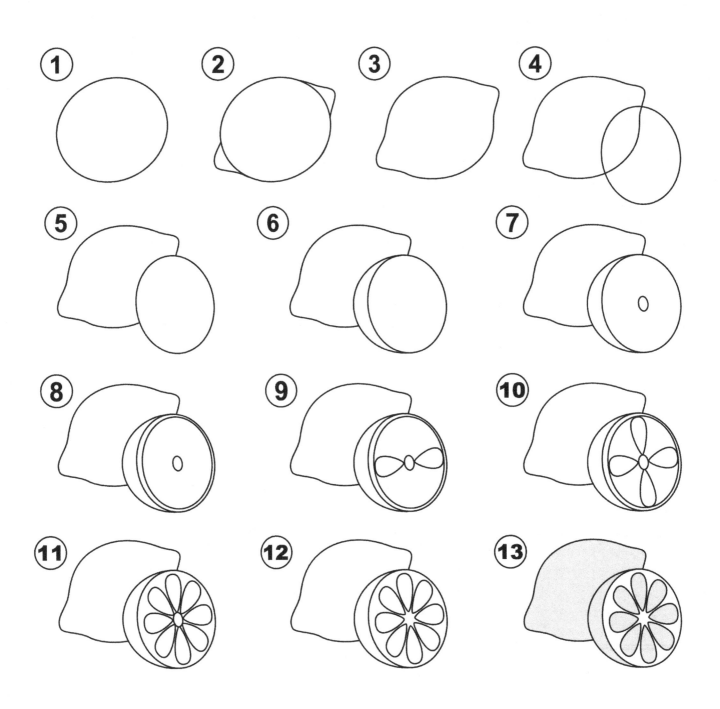

Your Turn to Draw

Cherries

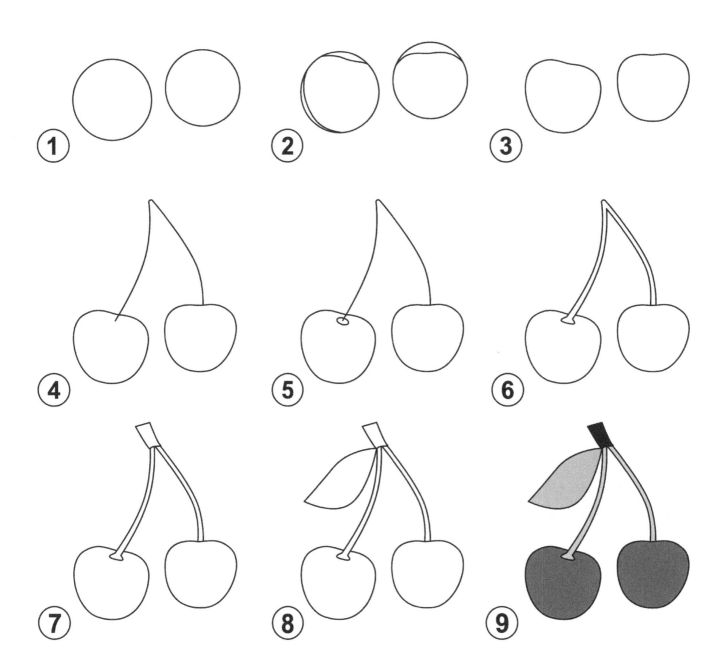

Your Turn to Draw

Swan

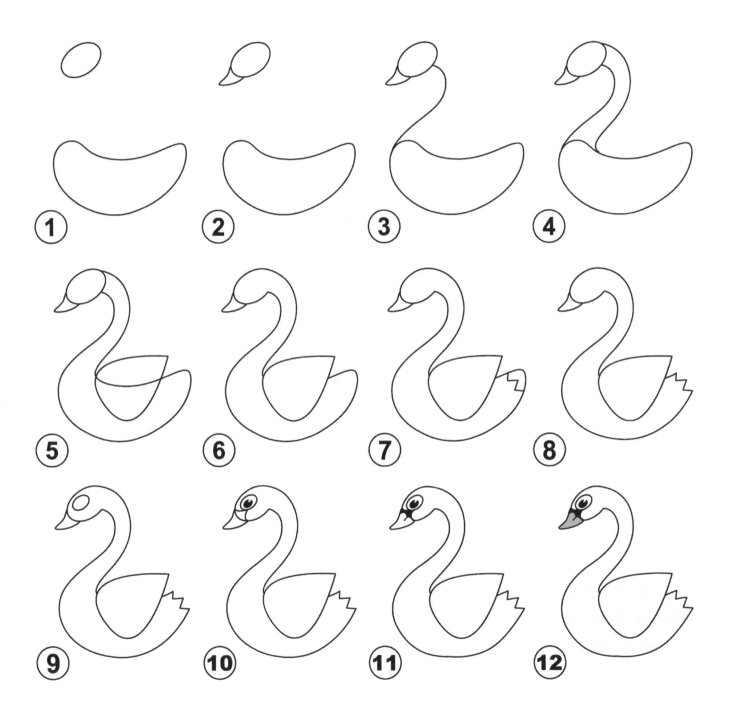

Your Turn to Draw

Teacup

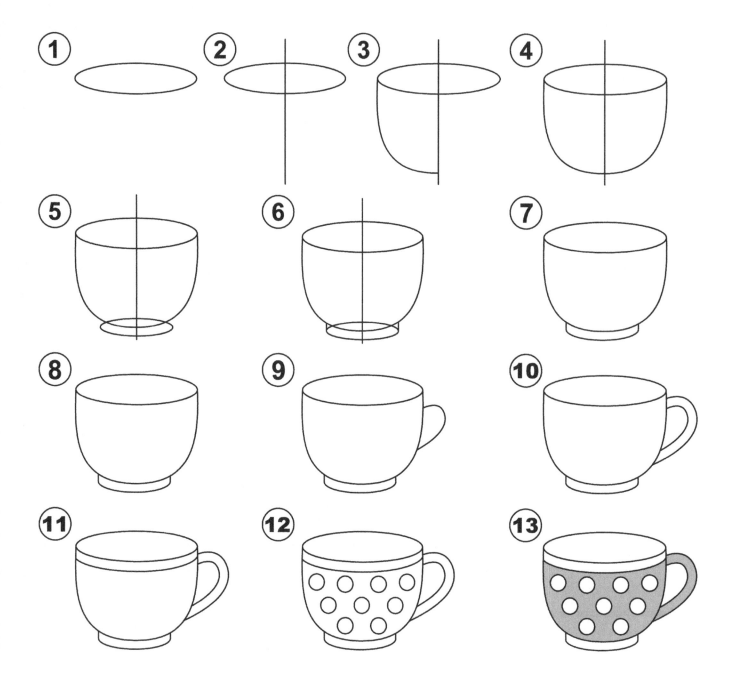

Your Turn to Draw

Dinosaur

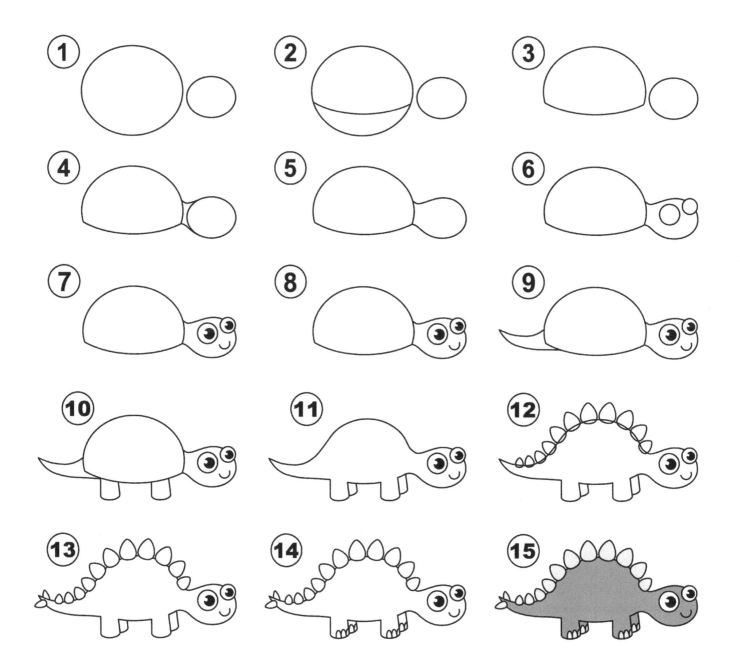

Your Turn to Draw

Clouds

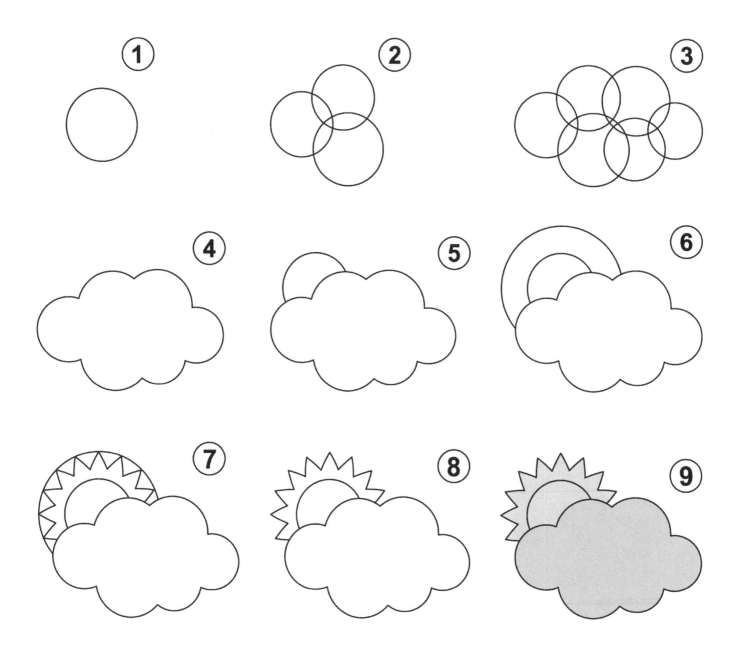

Your Turn to Draw

Anchor

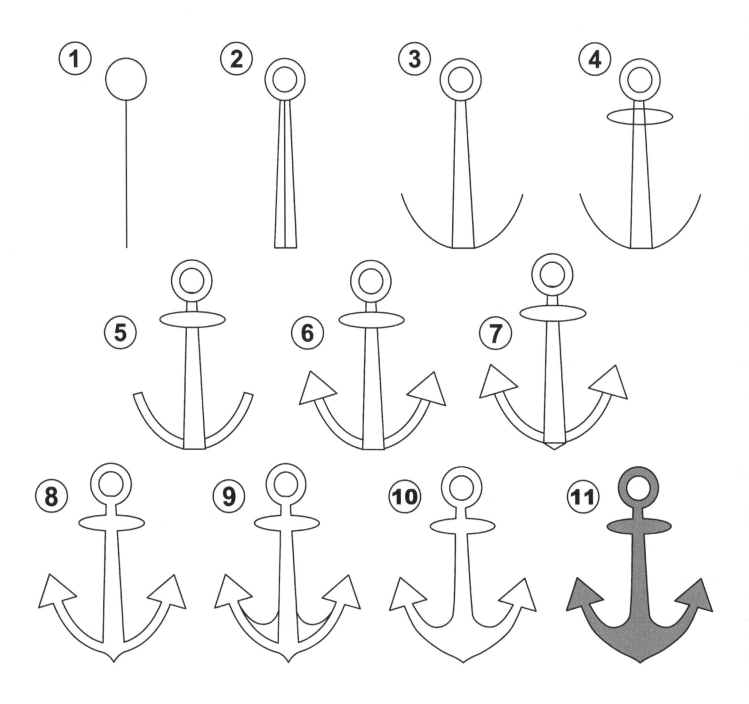

Your Turn to Draw

Dragon

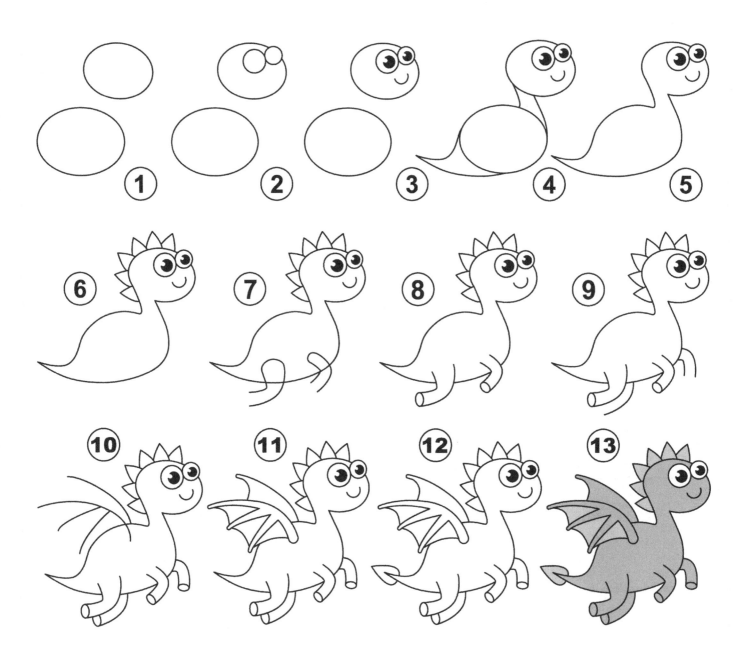

Your Turn to Draw

Flag

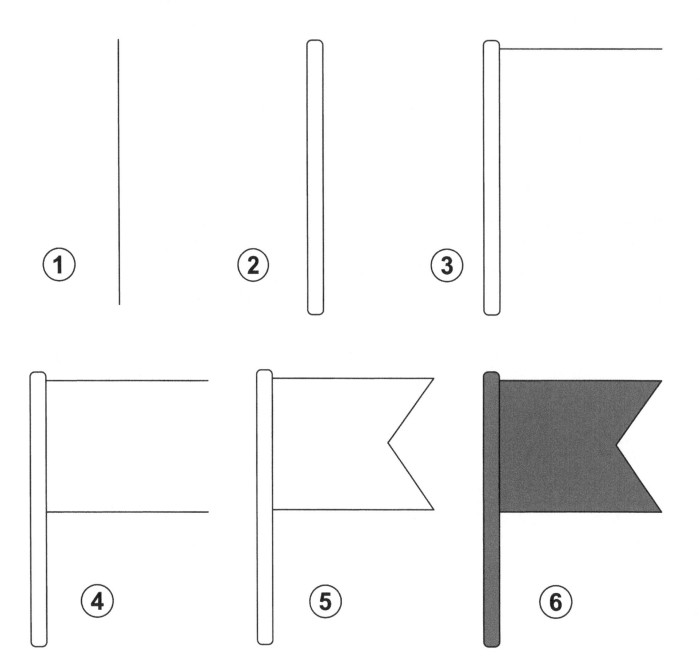

① ② ③ ④ ⑤ ⑥

Your Turn to Draw

Beach Ball

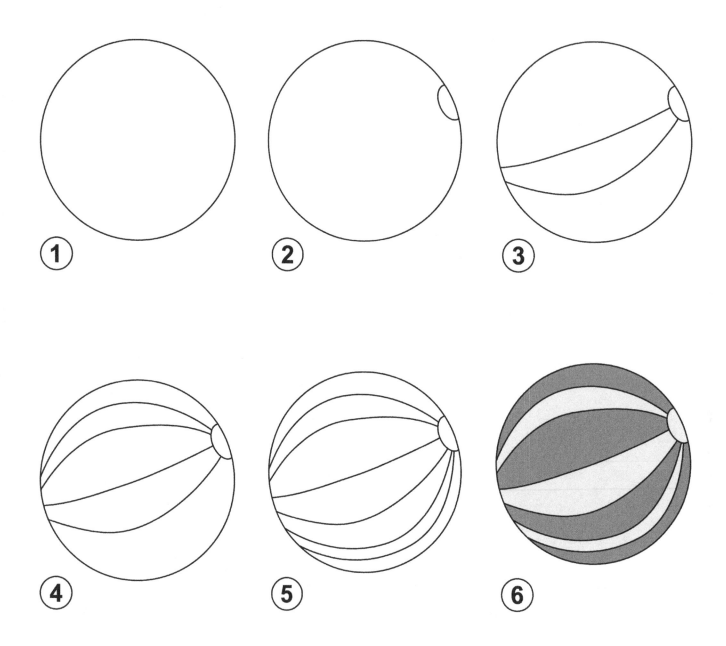

Your Turn to Draw

Watch

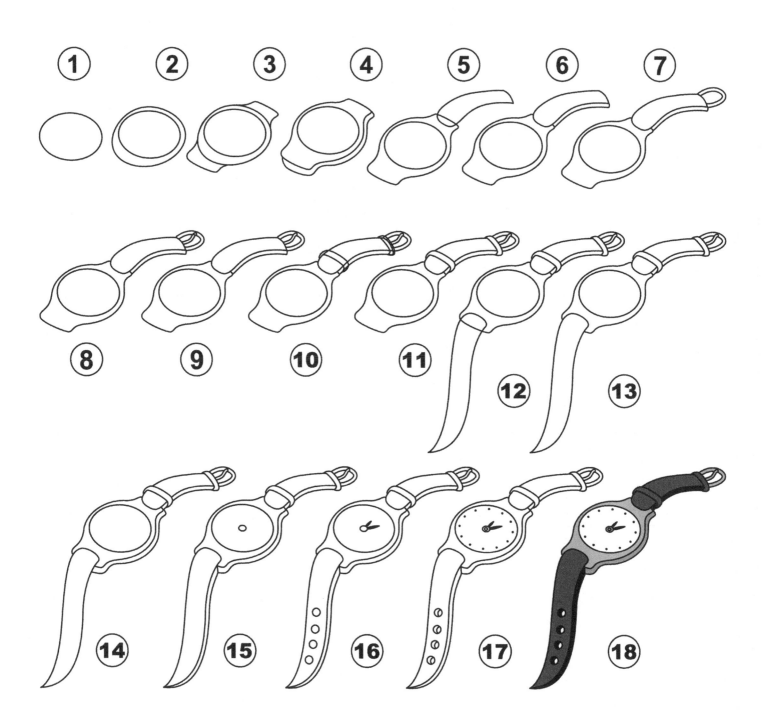

Your Turn to Draw

Bird

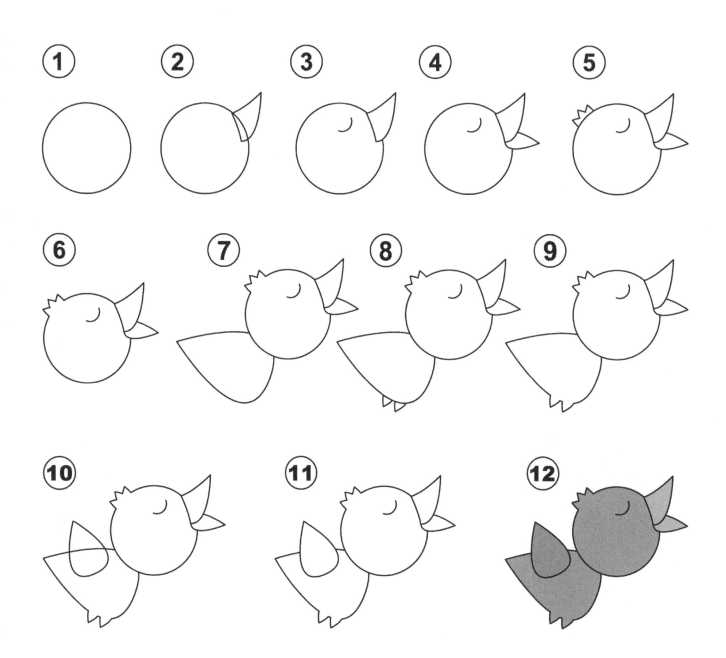

Your Turn to Draw

Watermelon

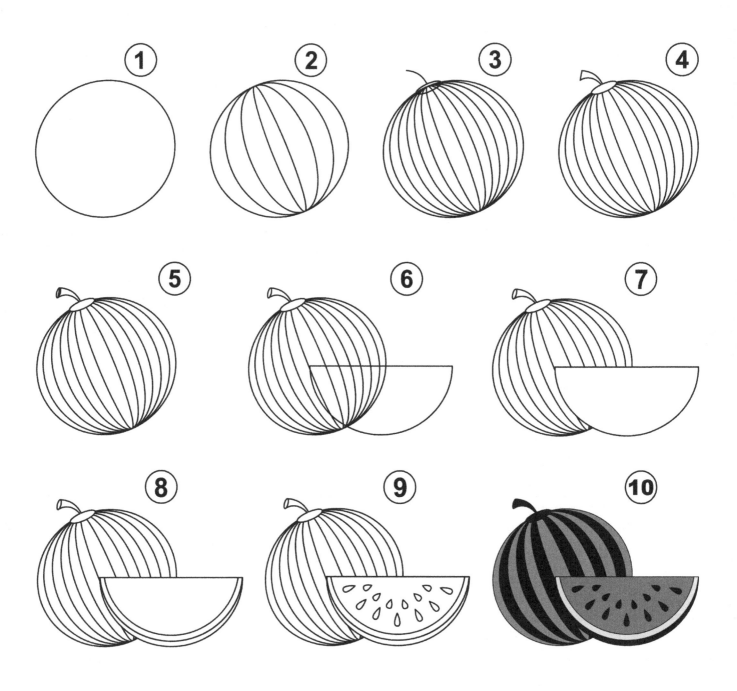

Your Turn to Draw

Bumblee Bee

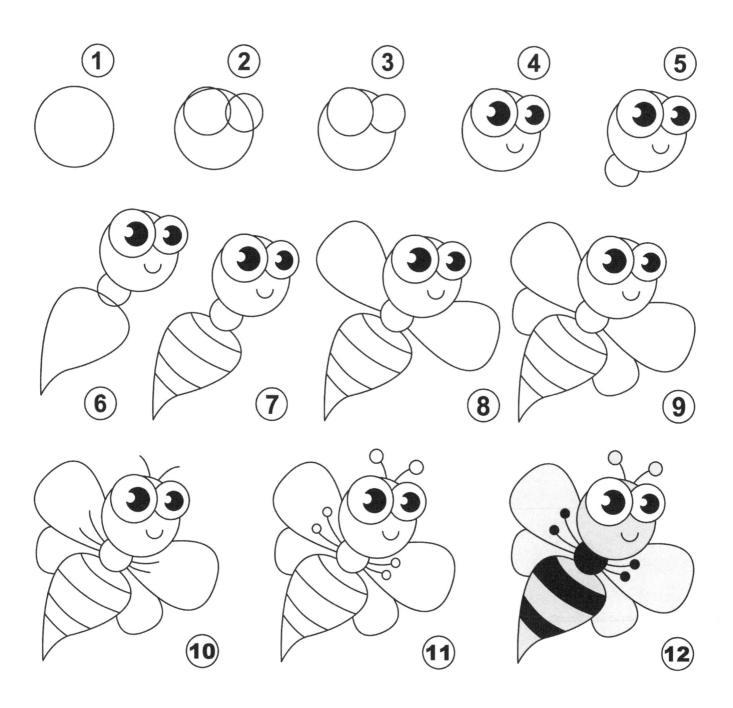

Your Turn to Draw

Butterfly

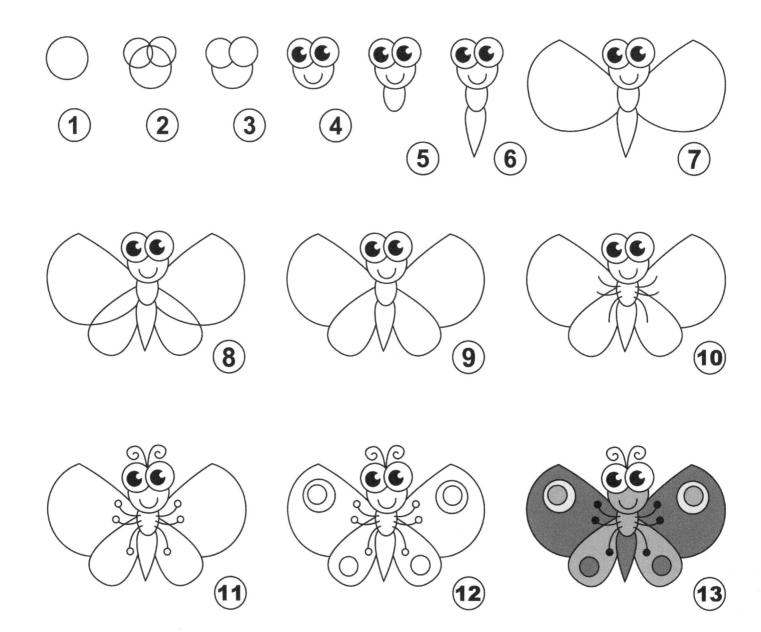

Your Turn to Draw

T-Rex

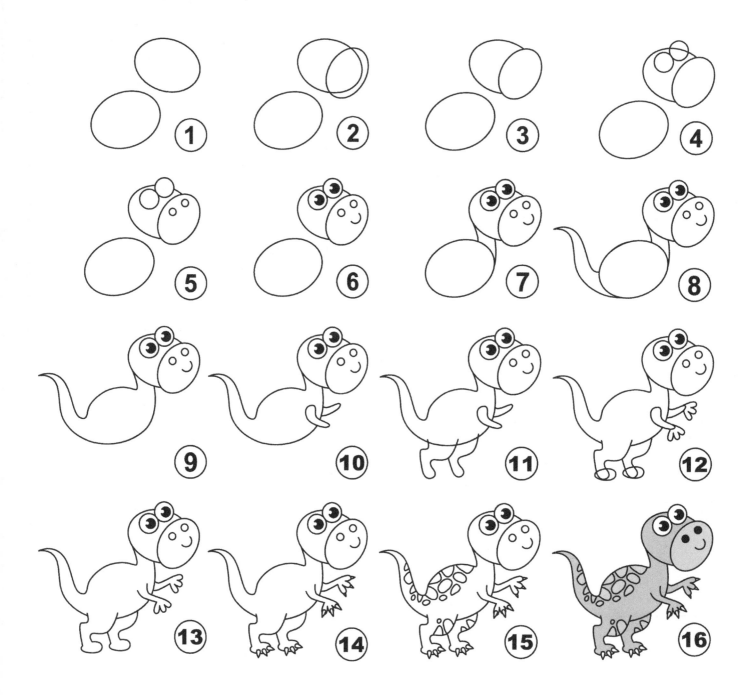

Your Turn to Draw

Grapes

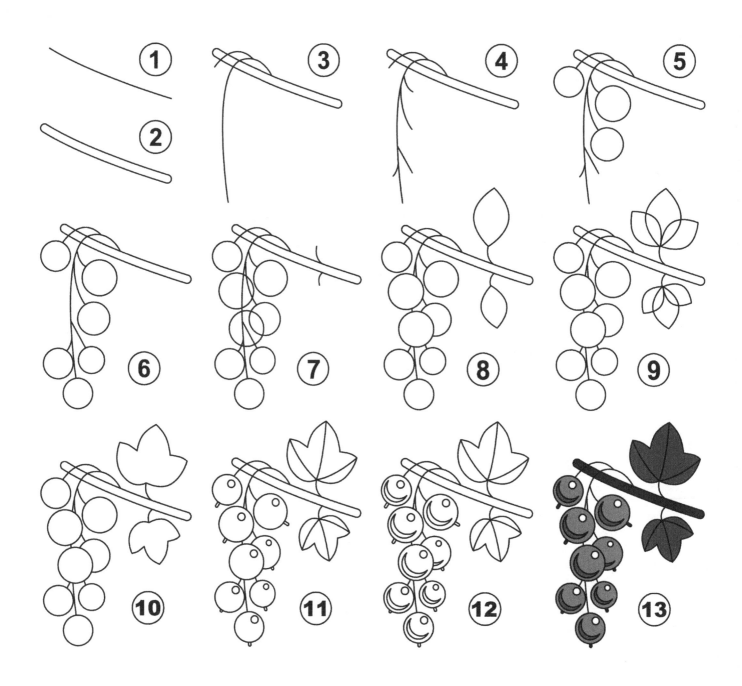

Your Turn to Draw

Orange

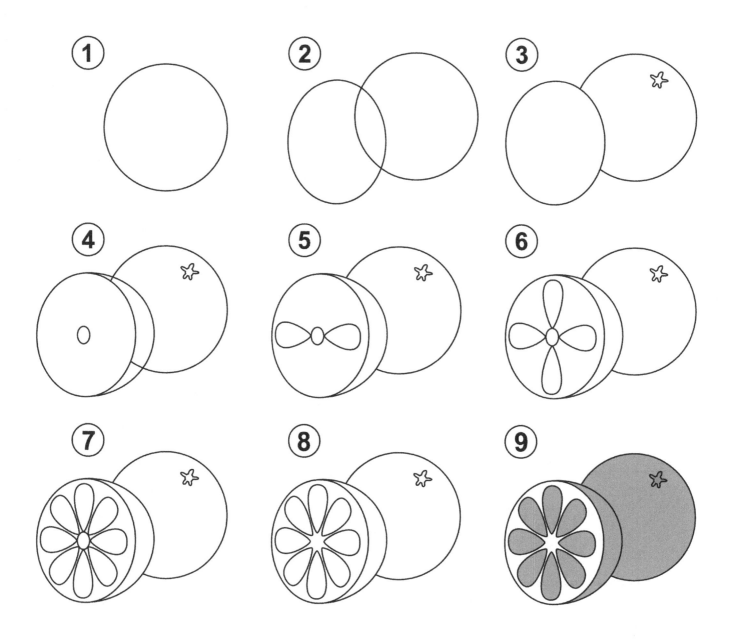

Your Turn to Draw

Snail

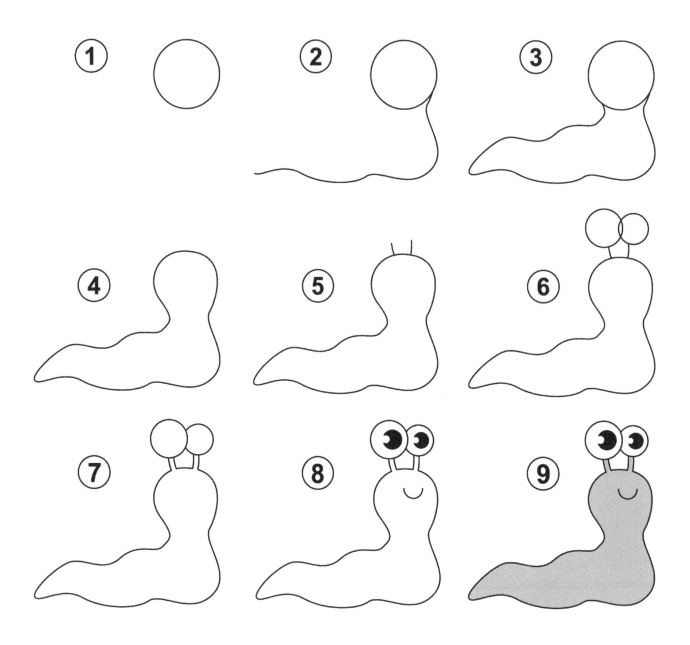

Your Turn to Draw

Submarine

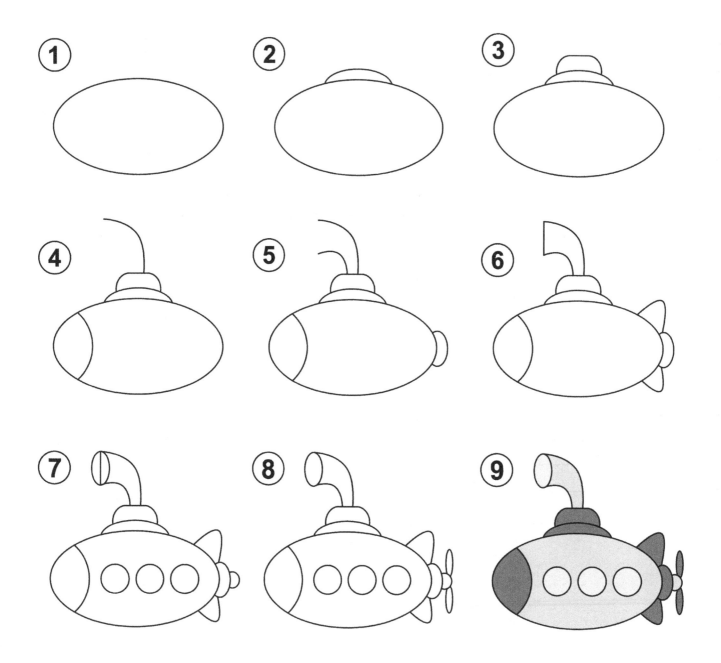

Your Turn to Draw

Spaceship

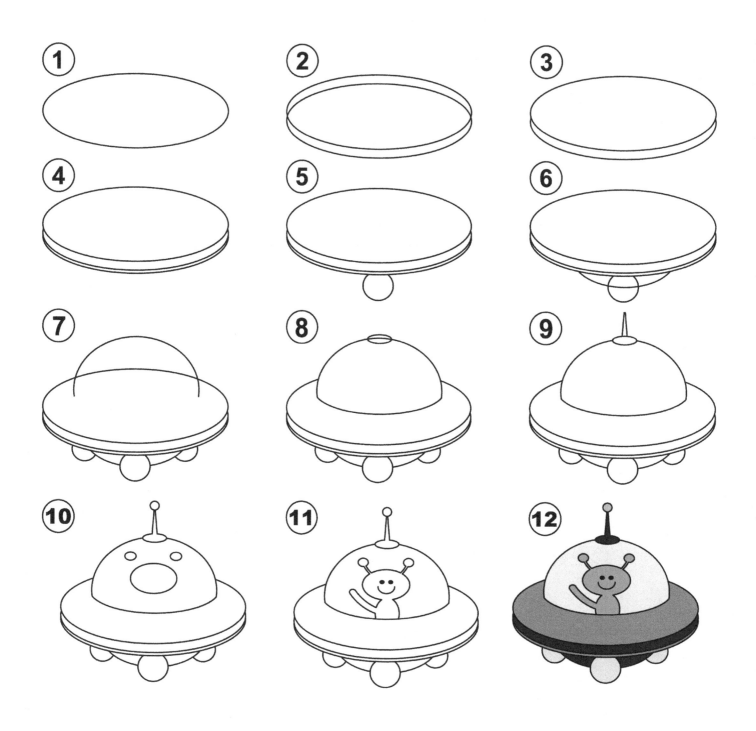

Your Turn to Draw

Lamp

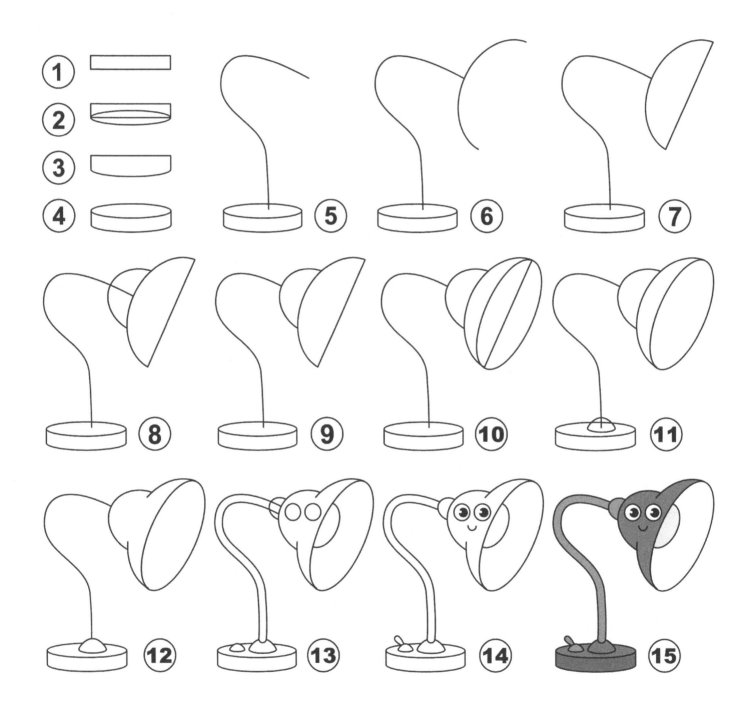

Your Turn to Draw

Balls

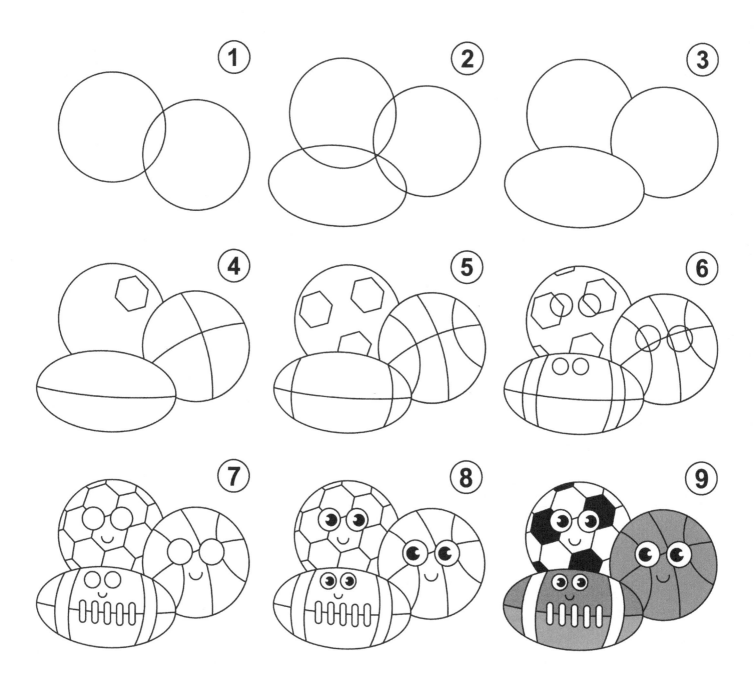

Your Turn to Draw

Calculator

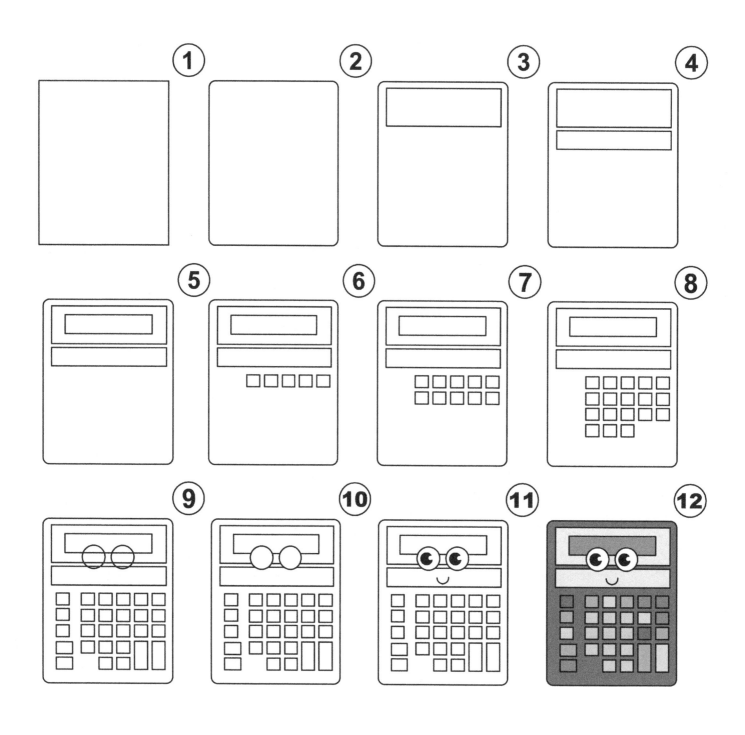

Your Turn to Draw

Fish Bowl

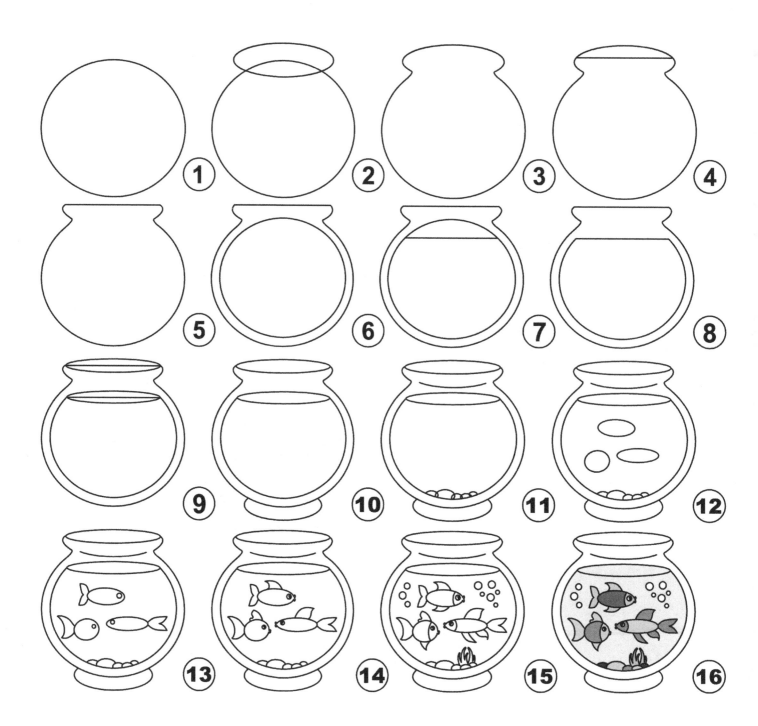

Your Turn to Draw

Owl

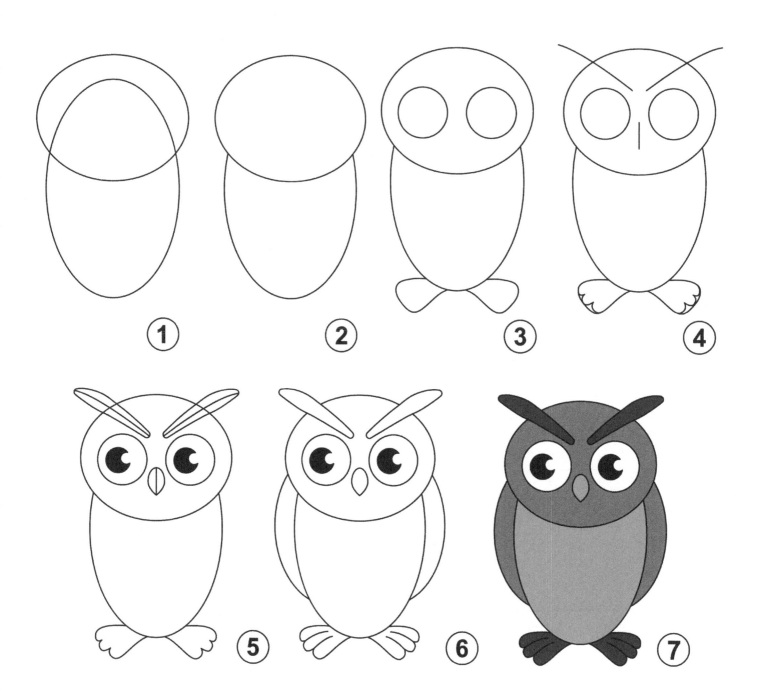

Your Turn to Draw

Rose

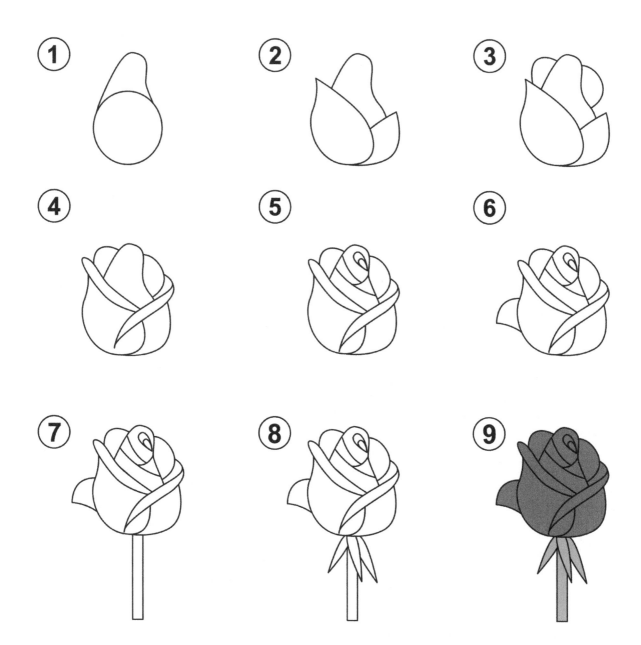

Your Turn to Draw

Heart

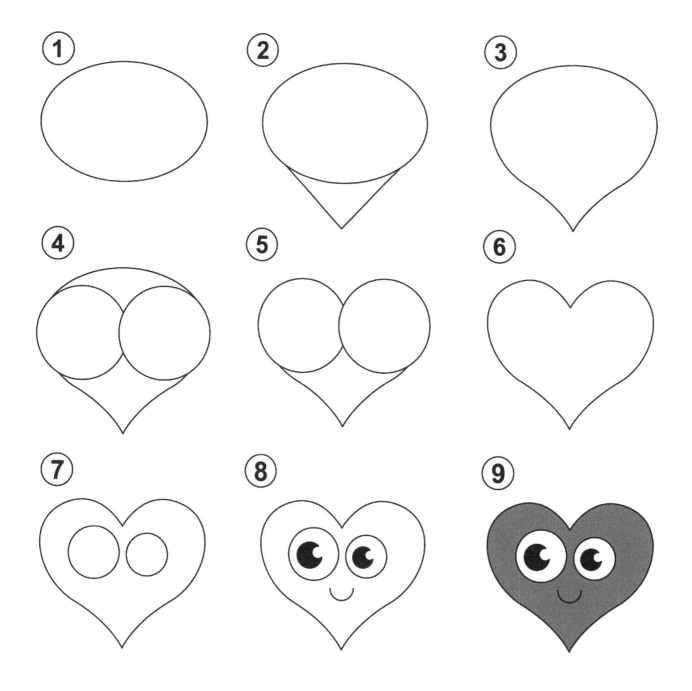

Your Turn to Draw

Puppy

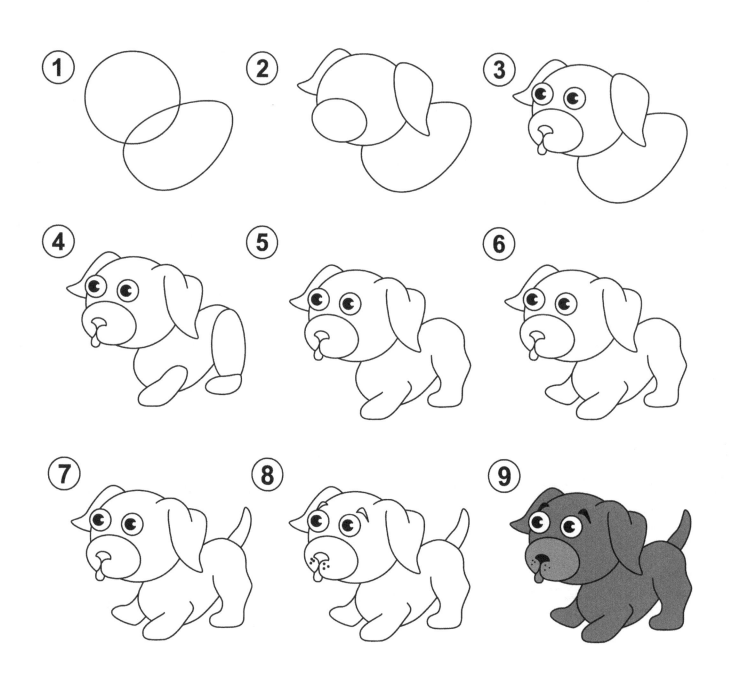

Your Turn to Draw

Made in the USA
Coppell, TX
22 October 2019